What to draw with

Never be intimidated by a piece of white paper. Make an attack, dominate your drawing and be prepared to experiment. A useful exercise is to make a bold, random scribble with charcoal or soft crayon on a large sheet of paper and then draw into it to tidy it up.

I have set out here the marks made by different drawing materials.

a willow charcoal; **b** charcoal pencil; **c** carbon pencil, hard and soft; **d** conté crayon, slightly more greasy than charcoal or carbon; **e** red chalk, or sanquine; **f** wax crayon; **g** medium pencil, HB; **h** soft pencil, 2B to 6B; **i** hard pencil, H, useful for

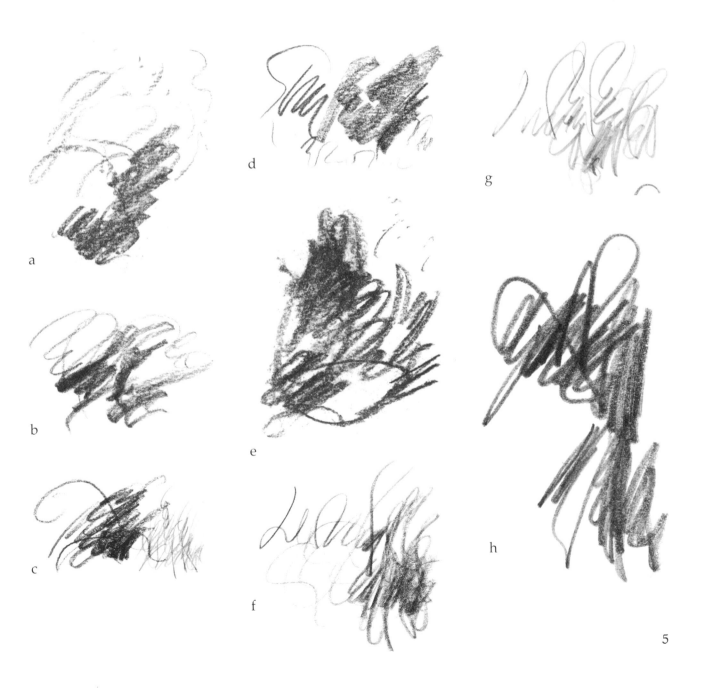

a

b

c

d

e

f

g

h

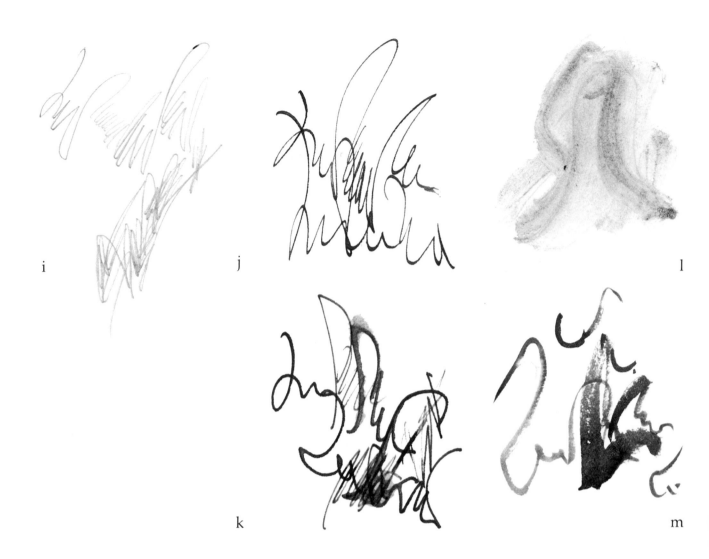

i j l

k m

fine detail; **j** pen and ink (steel nib); **k** pen and ink (bamboo pen); **l** ink wash (large brush); **m** ink line (small brush).

The drawings on the next three pages show how you can use these various materials and which go well together.

Draw
Figures in Action

EAST BERKSHIRE COLLEGE
LEARNING CENTRE
WINDSOR

St. Leonards Road, Windsor SL4 3AZ
Telephone: **01753 793121**

A & C Black • London

First published in 1981
New style of paperback binding 1997
By A&C Black Publishers Limited
38 Soho Square, London W1D 3HB
www.acblack.com

Reprinted 1999, 2004, 2007

ISBN-10: 0-7136-8324-4
ISBN-13: 978-0-7136-8324-0

Cover design by Emily Bornoff

Printed in China by WKT Company Limited

This book is produced using paper that is made from
wood grown in managed, sustainable forests. It is natural,
renewable and recyclable. The logging and manufacturing
processes conform to the environmental regulations
of the country of origin.

Contents

Making a start

In this book I have tried to work out a basically simple and traditional approach to drawing the mobile figure which can be developed in any way you choose, for fine art drawing, illustration or studies for painting.

Figures in action cannot be drawn from a posed model, so you must rely on your own observation, reinforced with some knowledge of anatomy and perspective and of how the body works in movement. I have kept the method as simple as possible, but if you are a serious student I urge you to study these subjects in more detail.

One of the most important qualities of a drawing is that it should be life-enhancing. Your ability to give life to a drawing will improve if you aim for rhythm, variation of line and tone, and accentuation.

Most of the drawings in this book are accompanied by a directional study, a loose working drawing which searches out the basic composition and shapes—to this 'schema' a more incisive notation is then added. For this kind of preliminary drawing, keep your hand moving as freely as possible.

If at any stage—even after a few lines—you feel that your drawing has become alive or conveyed what you want to say, stop, and make another study. Each one will be different if you are drawing freely, and you will learn something at each attempt. There is no need to make a final, detailed statement until you are sure of your basic lines and forms.

The finished studies illustrate how far a drawing can be taken. A private note is often more prized than a complete statement and its ambiguity may be appealing, but attempting a finished drawing will increase your ability to gather information and make selections.

The discipline and observation required in figure drawing demands constant practice. If you alter the dimensions of a house or a tree it will remain a house or tree, but altering the dimensions of the human figure immediately creates a caricature or grotesque.

I hope the method demonstrated here will provide a sound structure on which to develop exciting work.

Willow charcoal on the rough side of grey wrapping paper. For charcoal, use a fixative spray to prevent smudging.

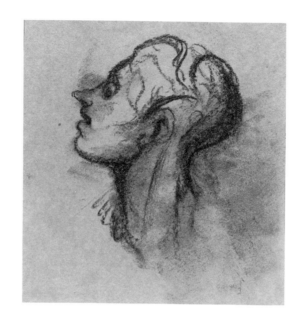

Willow charcoal on the same paper, highlighted with white chalk. The details (eye, mouth etc.) are strengthened with a charcoal pencil (either hard or soft) which is firmer and a more intense black.

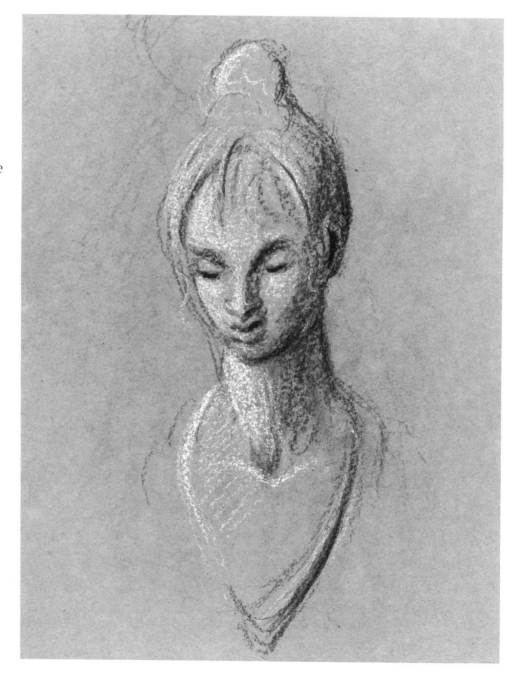

Drawn lightly with
willow charcoal, fixed,
then finished with more
concise drawing using an
HB pencil.

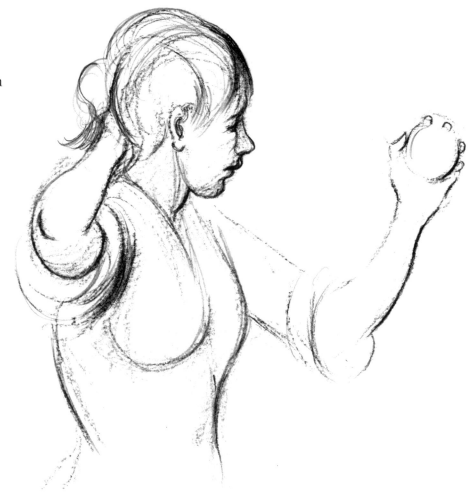

Drawn with a carbon
pencil, which is firmer
and less grainy than a
charcoal pencil.

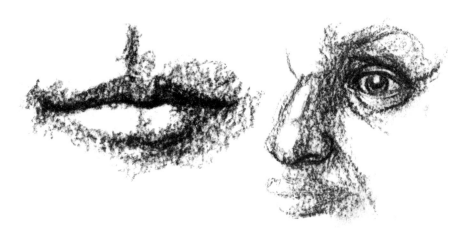

Three drawings in red
chalk on a slightly toned
paper. The lines in the
mouth are carbon pencil,
the eye and nose have
some modelling in white
chalk.

A pen and ink drawing,
using a metal nib. This is
excellent for detailed
work. The drawing can
be lightly sketched in first
with pencil.

An ink drawing using a
bamboo pen. This is
similar to the old quill
pen in the variation it can
give to the line.

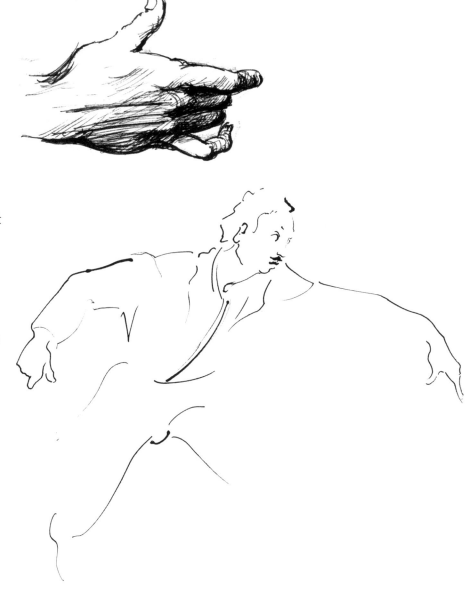

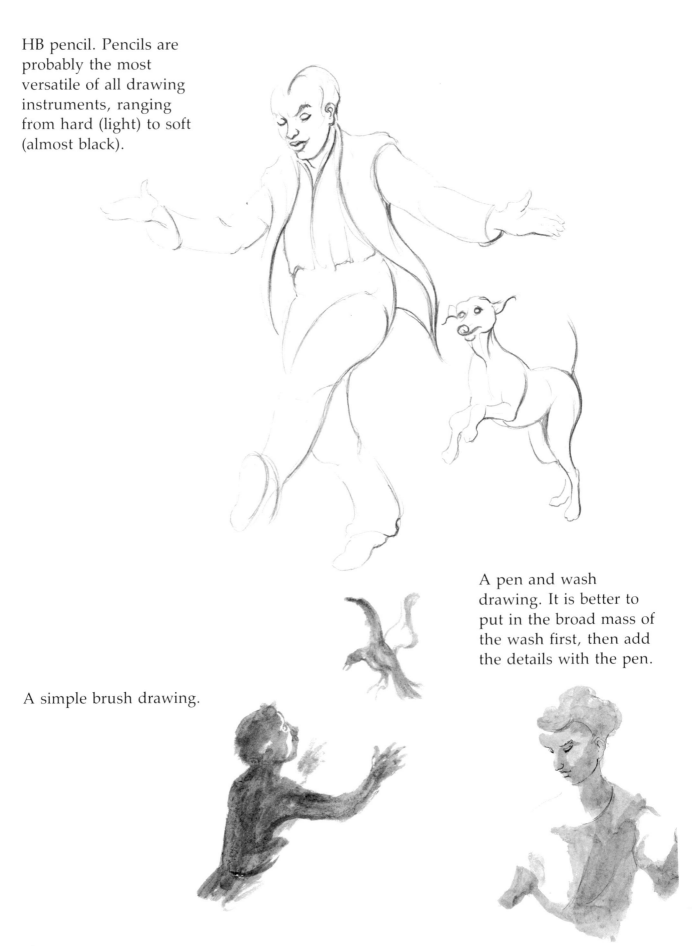

HB pencil. Pencils are probably the most versatile of all drawing instruments, ranging from hard (light) to soft (almost black).

A pen and wash drawing. It is better to put in the broad mass of the wash first, then add the details with the pen.

A simple brush drawing.

What to draw on

Most paper nowadays is machine-made. The raw materials are selected from cotton, linen, esparto grass, straw and wood pulp, each giving different qualities.

With hand and mould-made papers the process is similar; the final stages of mould-made paper are mechanised. The natural finish of hand-made paper is a rough surface.

The boy playing a flute is drawn with a charcoal pencil on hot pressed mould-made paper, as are most of the drawings in this book. Hot pressed paper has a smooth surface.

The cheaper, machine-made shiny papers are good for pen and ink, as is card, but they are unsympathetic for pencil drawing.

Ledger Bond (cartridge in the UK) is a good all-purpose drawing paper, available in a variety of surfaces—smooth, 'not surface' (semi-rough) and rough.

Papers are usually treated with size, which makes them water-resistant. Unsized paper is used by watercolourists because it absorbs water more readily.

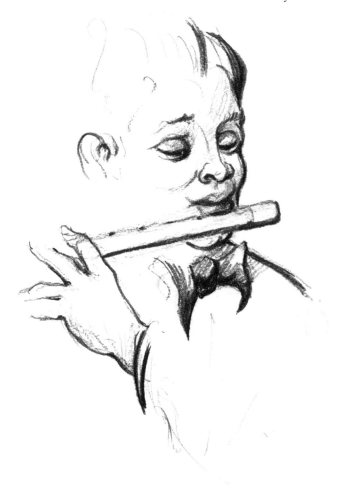

Perspective

For any representational drawing you need a rudimentary understanding of perspective. The body, like any other object or volume that takes up space, appears larger or more projected when close to the viewer and smaller as it recedes into the distance, and its proportions appear to alter. This is called foreshortening.

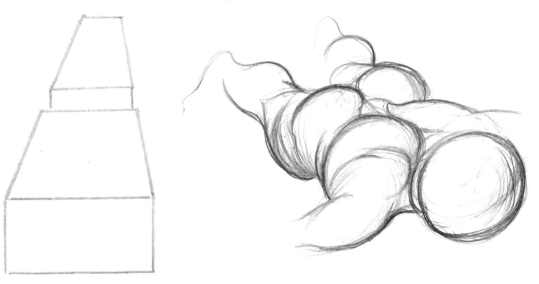

In this drawing of a reclining figure, the head appears much larger in relation to the length of the legs than it is in reality.

When the head is tilted away from you, the chin appears large and the forehead is cut off or greatly reduced in depth. The nose is also foreshortened and the nostrils become fully visible.

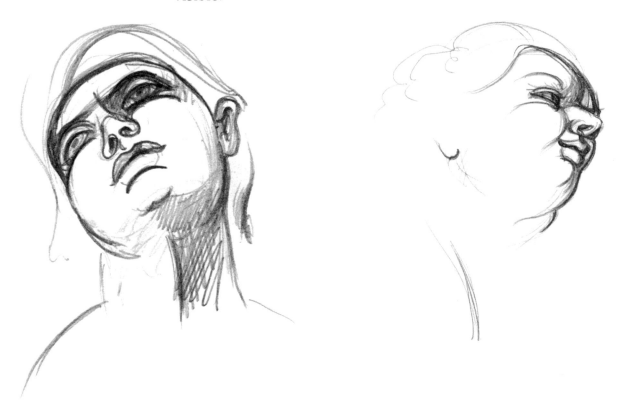

Any part of the body that is projected towards you will appear foreshortened; the proportions will vary depending on your viewpoint. For example, a hand held out in front of the face will appear much larger in relation to the head when seen from close up, and will reduce in size as you move away. (Try standing close to a mirror with your own hand outstretched, and then move slowly backwards.)

Monumental sculptors, faced with the problem of an elevated pedestal, had often to reverse this process and enlarge the portion furthest from the eye so that it would appear in proportion to the viewer.

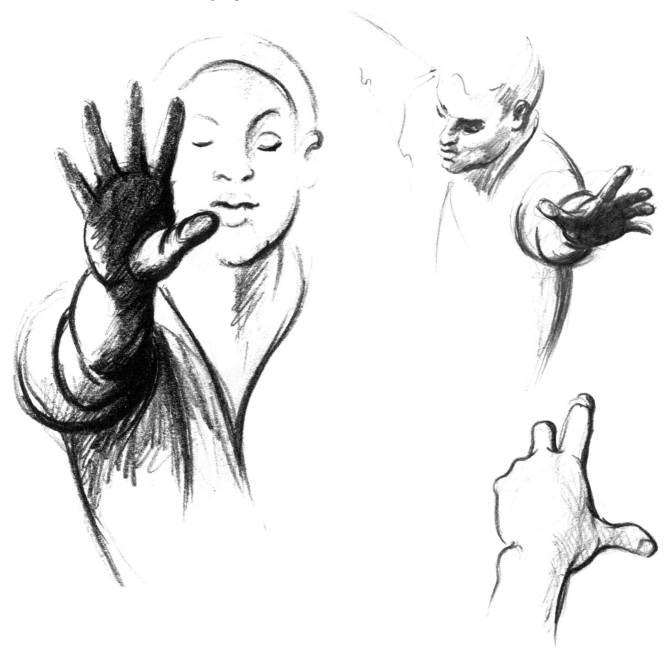

To create the effect of proximity and projection, note carefully the relative proportions of hand to arm, or foot to leg, and how the different parts change shape as they move or as your viewpoint changes, Observe how the length of an arm or leg is apparently reduced by foreshortening.

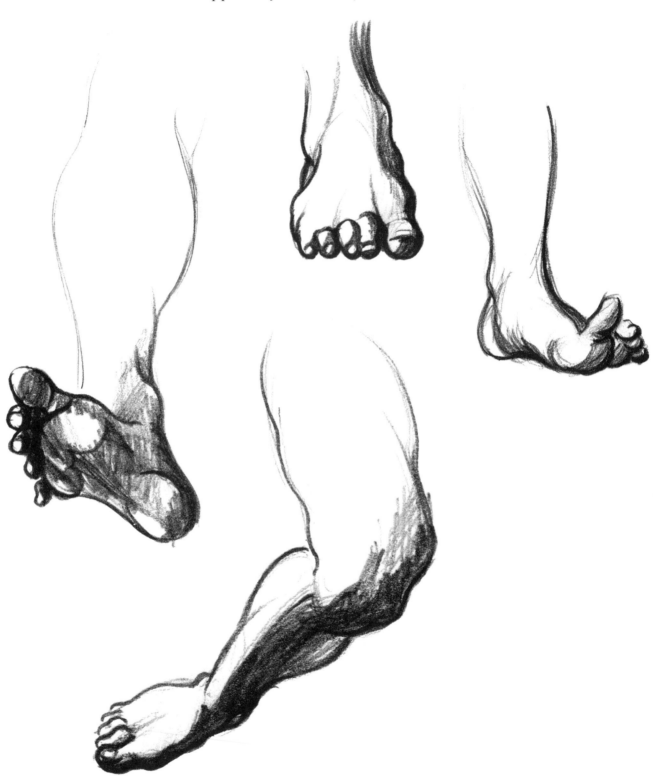

Boys painting a classroom. This is an illustrative drawing of figures in space. The lines of the floor, ceiling and blackboard, which are all parallel, recede to a vanishing point at eye-level. (In this case, the vanishing point is beyond the edge of the drawing.) The children also recede in size along these lines, so that the boy furthest away appears much smaller than the nearest one.

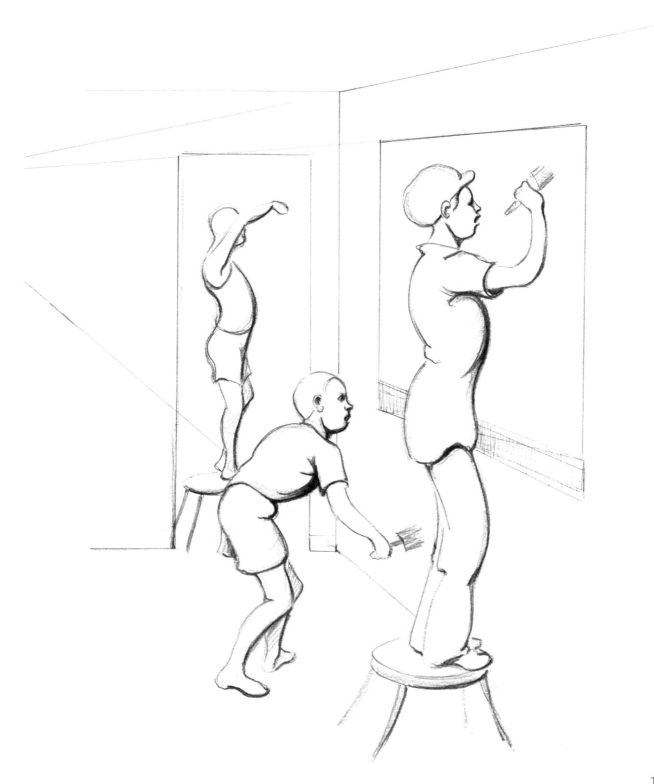

This drawing of children skipping is similar to the one on the
previous page, but here the children remain on one plane
(they are all at an equal distance from the viewer on a line at
right angles to the line of vision) while the building and
window recede into space. The eye-level is at the window sill
and the receding lines meet at a vanishing point at the edge of
the drawing.

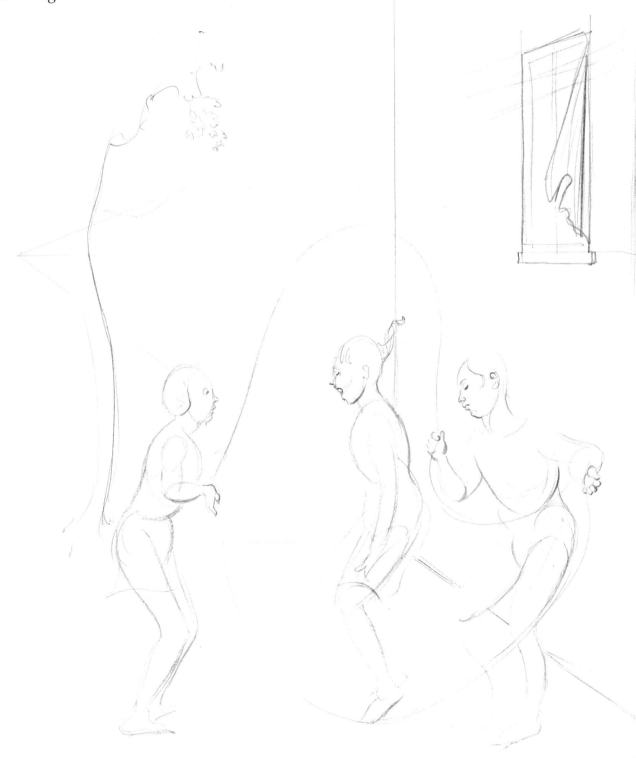

The problem of
perspective also appears
in some of the drawings
in the section on
composition later in the
book.

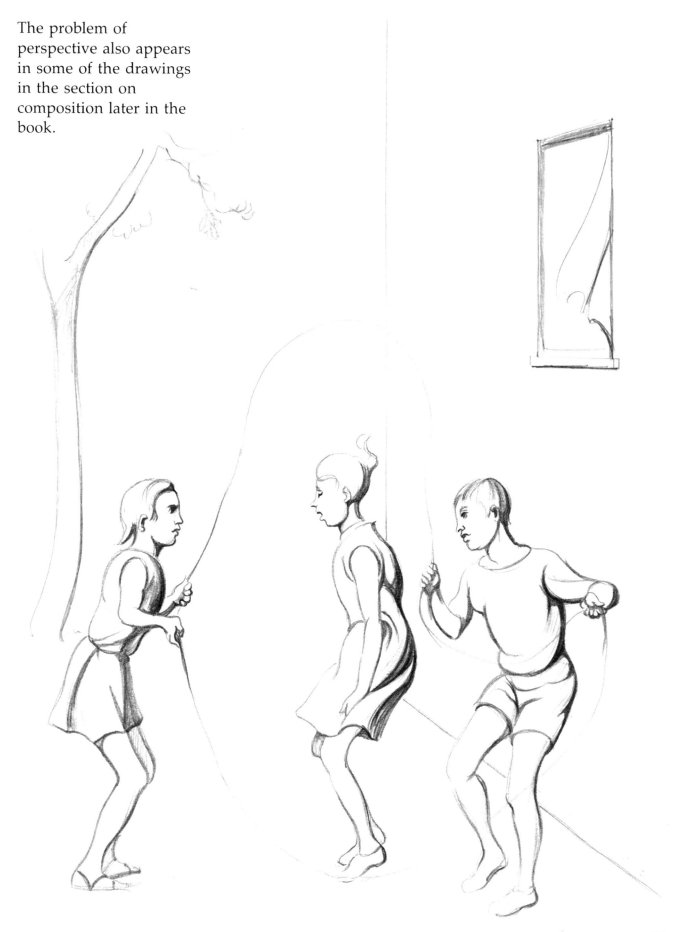

Basic anatomy

An awareness of the bone-structure beneath the flesh will help to make your drawing convincing. It is not possible in a small book to describe human anatomy in detail, but we can work out the general structure of the head, shoulders, rib cage, pelvis and limbs. If you understand this basic framework you can relate it to the shape of the figure seen from any angle. Here is the basic skeleton of a man, from behind. Remember that the joints are the springs which articulate movement. The shoulder blades form two triangles with sockets for the arms.

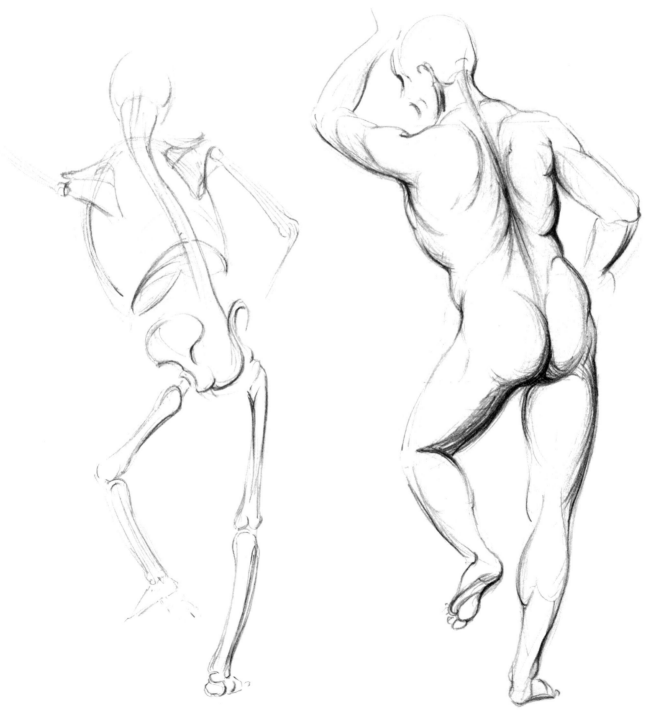

A man's skeleton from the front. Note the shape of the rib cage.

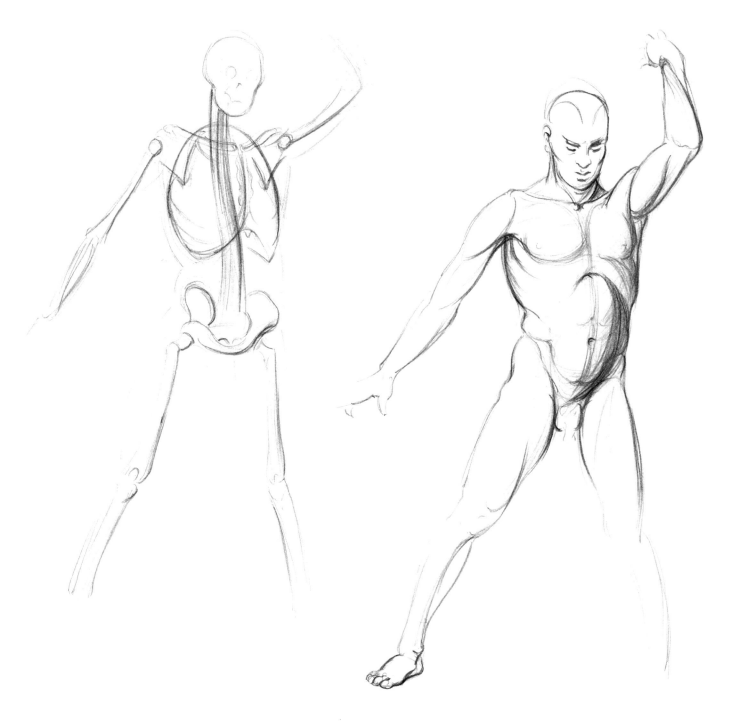

The skeleton seen from the side. Note how the spinal column links the head and the pelvis, and how the legs are hinged to the pelvis and jointed at the knees.

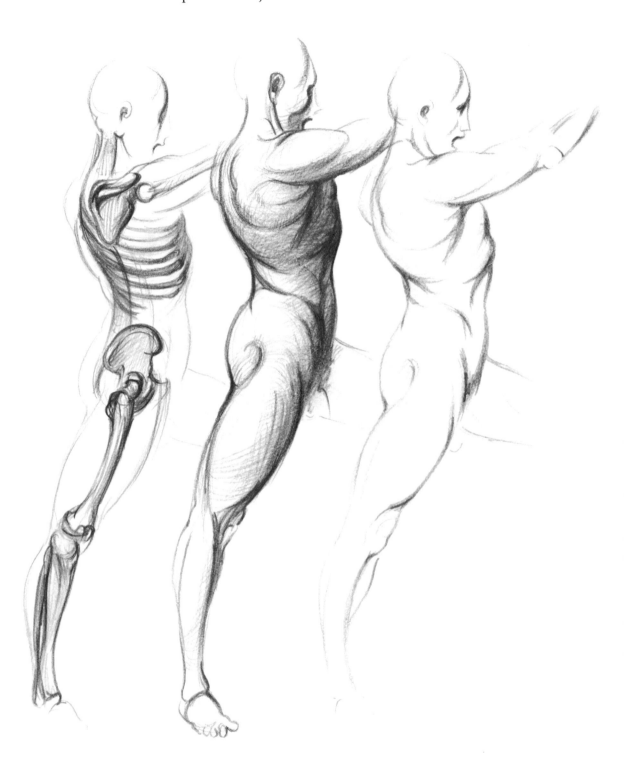

A man bent forward. Note how the rib cage overlaps the pelvis in the skeleton drawing, and that the collar bones are prominent.

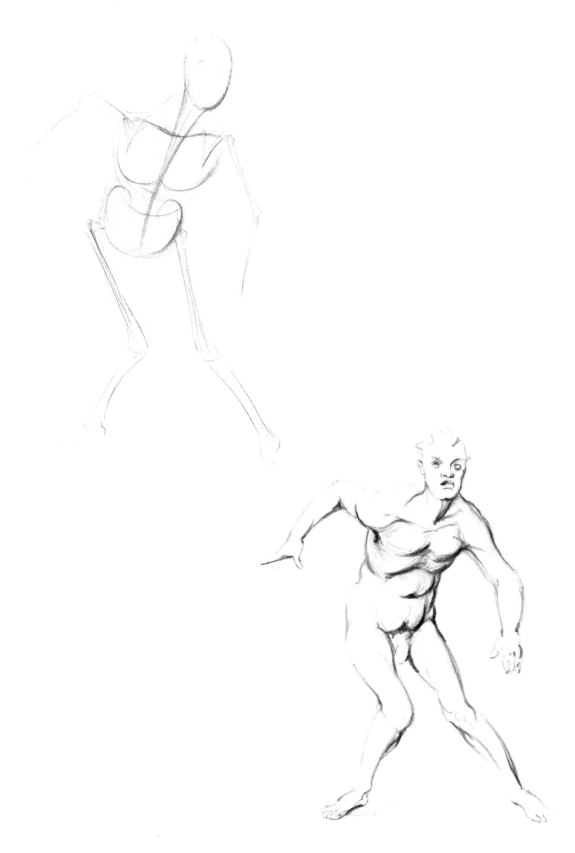

The woman's skeleton is basically the same as the man's, but the pelvis is wider and the shoulders are narrower. A woman's bones are usually covered with more flesh than a man's, giving a softer, less muscular outline, and the frontal appearance is altered by the shape of the breasts.

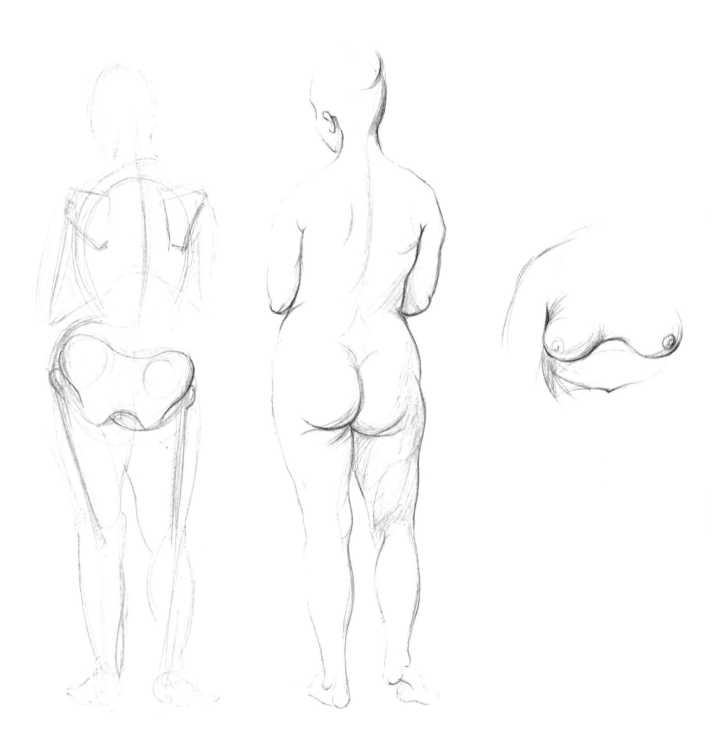

These studies show the skeleton at work, in different positions. Do as many drawings of your own as you can in this way, trying to get the proportions correct. Then begin to fill them out.

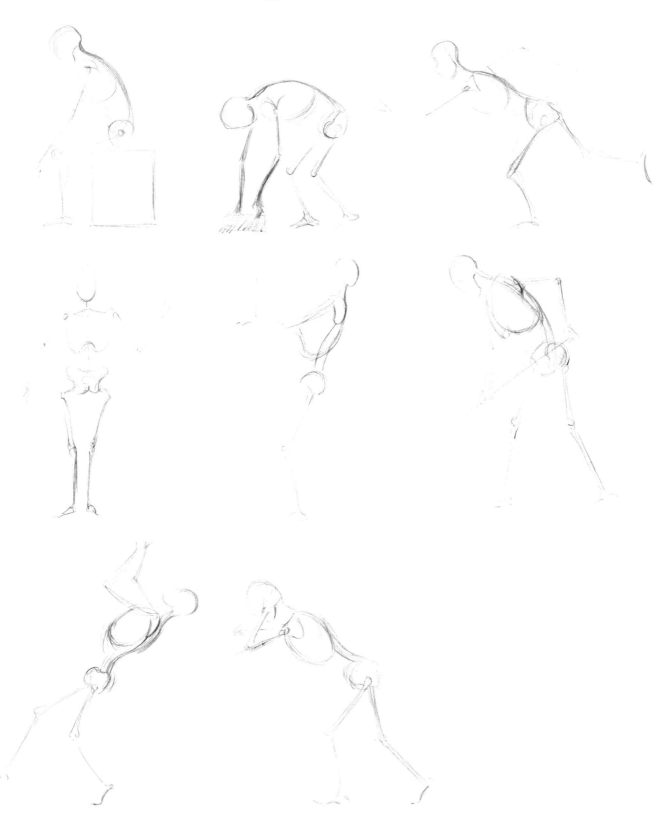

Clothes

These drawings of a boy and a woman flying kites show how clothes take the shape of the body underneath them. Try to search out the basic forms of the figure, keeping in mind the skeletal structure. Make small studies of how the fabric creases and folds around the joints. Ill-fitting clothes can look like a bundle of rags, obscuring any sense of form underneath.

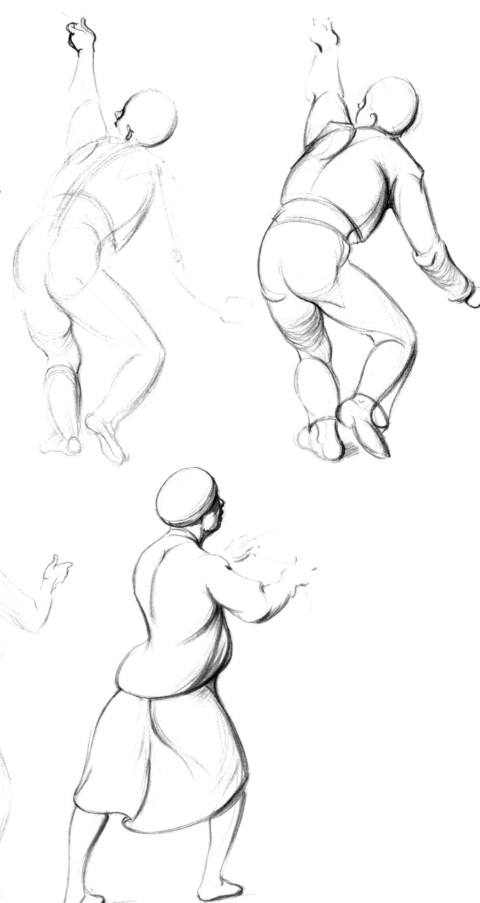

The movement of the figure also affects the drapery of clothing. A loose coat or skirt will flow out behind a running figure. Make some practice drawings and design over the basic form the lines and shapes you think the clothes will follow. Experiment with flying drapery.

These sketches are examples of 'directional drawing'. The flow of the clothes helps to indicate the direction of the body movement. Don't be afraid to obscure your basic lines in your search for a satisfying design.

I have chosen an orchestral conductor to illustrate how a piece of clothing such as a tail-coat can create a shape at variance with the figure as a whole, but can add to the interest of the design or even give it an unusual or rather strange quality.

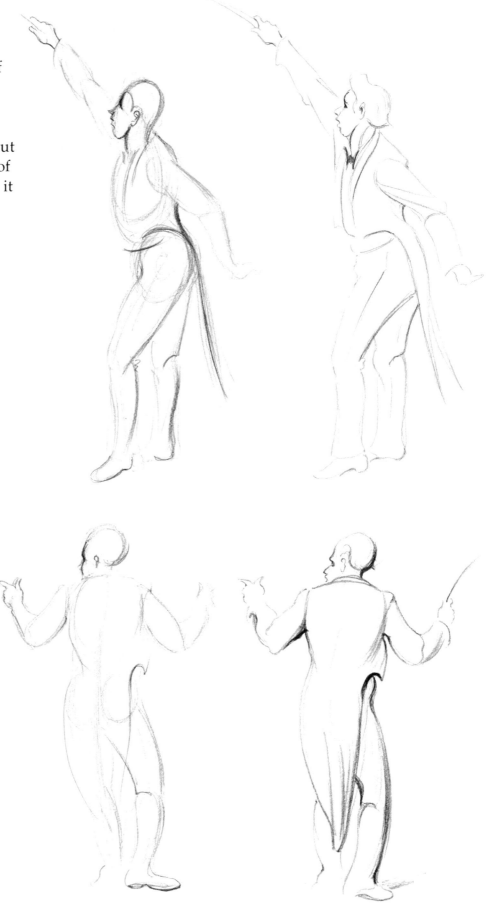

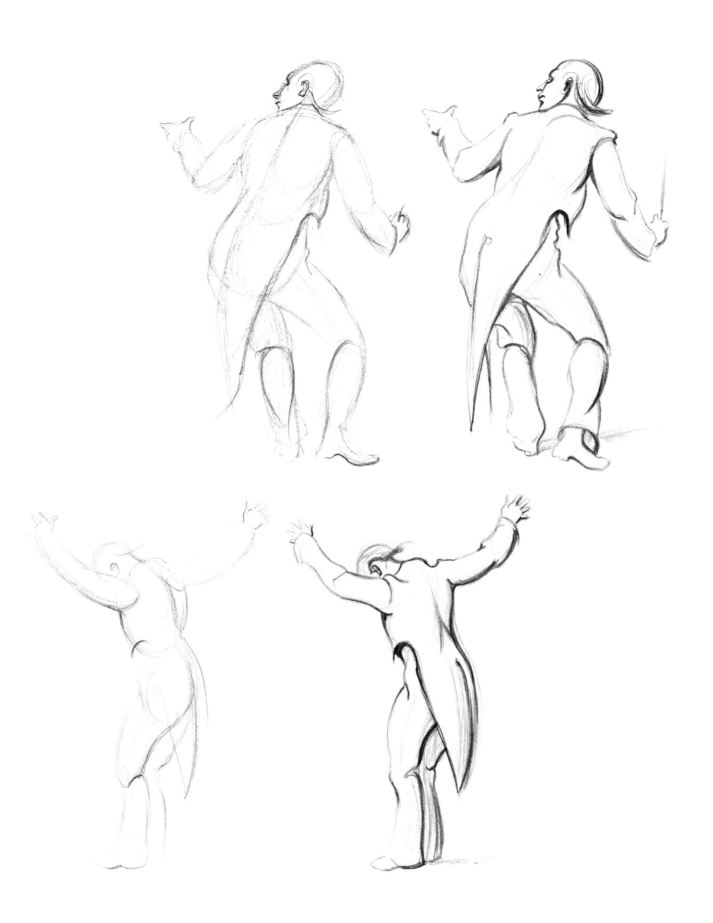

Movement

When you are familiar with the structure of the skeleton and how clothes fit over the surface forms of the figure, you can go on to study the problems of movement more carefully.

You cannot learn about movement from a posed model. It must be worked out from your knowledge of basic anatomy and from observation. Think about the distribution of weight and the point of balance, which vary as the figure moves.

This drawing shows a waitress standing poised, ready to move. A line of axis runs from the foot, up the front of the leg, through the centre of the body to the back of the neck, seeming to lock her in a rigid position.

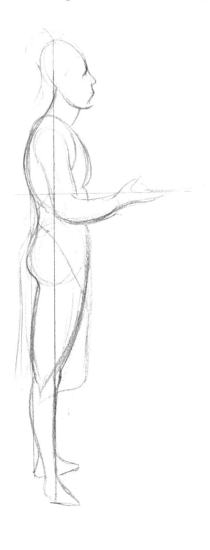

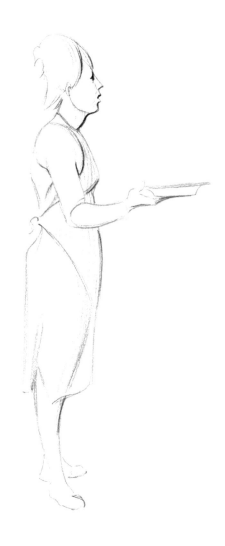

Your drawing must aim to create the illusion of movement. Here the waitress has moved from her rigid position, the knees are bent and the upper part of the body is tilted forward, so that the axis line rests behind her shoulder. The position of her outstretched arm and the tilt of the plate enhance the feeling of insecurity.

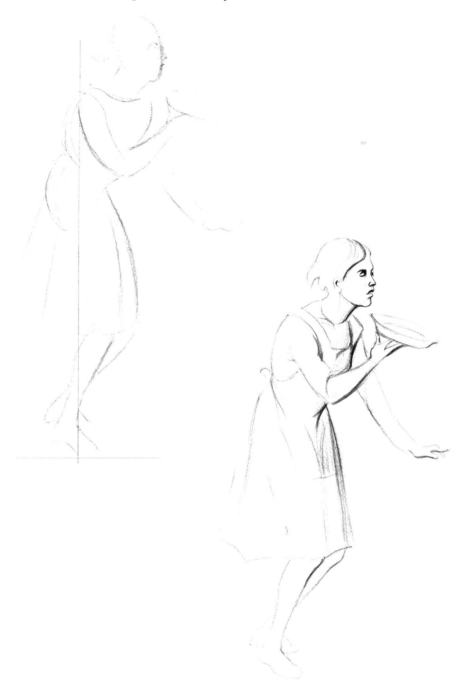

In this drawing, the waitress has moved out of the line of axis to a degree that requires extreme muscular exertion to save herself from falling, and the left arm is extended behind her in an effort to keep her balance. The addition of a small dog and an innocent diner give the drawing an illustrative meaning.

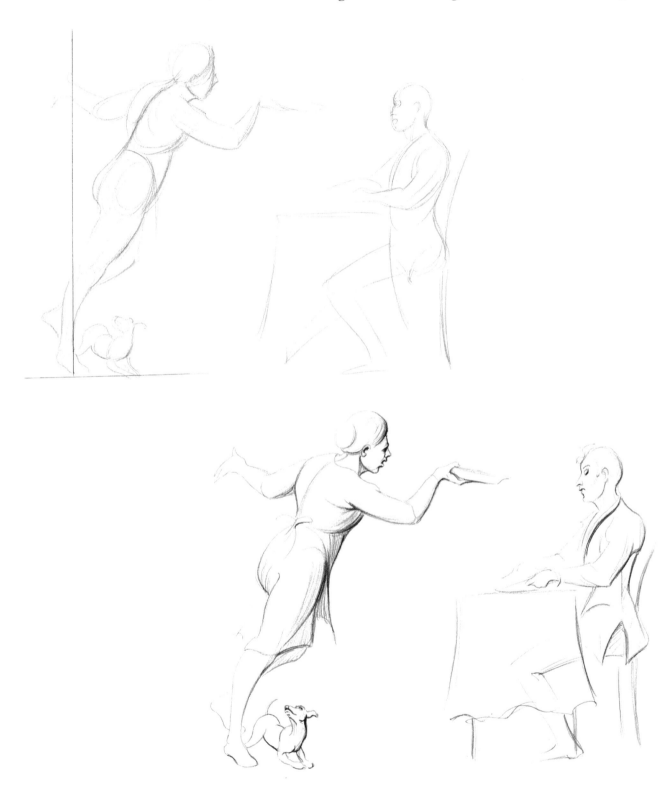

This drawing shows a high-jumper in action, caught in mid-air. But if you turn the page round, the figure appears to be running.

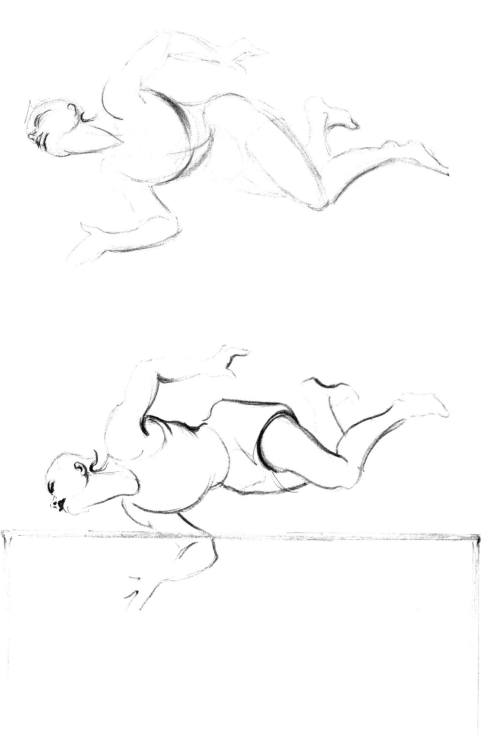

Variation of line

Try to vary the quality of line as much as possible in your drawing. Strengthen it where you want the eye to follow. Lighten it where you want the image to recede.

A varied line and accentuation of certain points and areas give life to a drawing. Decide where you want the accents to be. Too much evenness will produce a dull drawing.

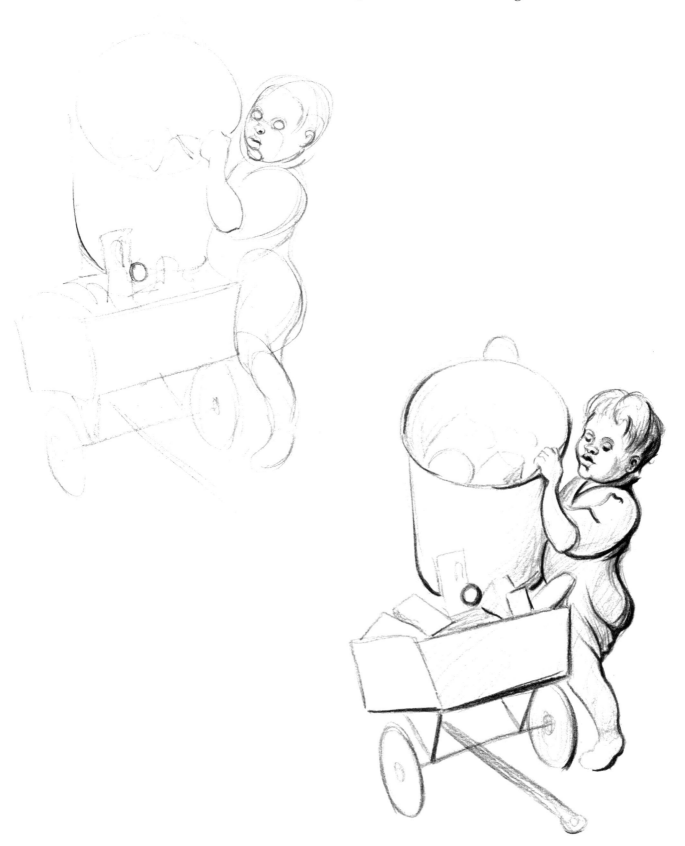

Composition

This is the art of combining objects or figures in a drawing so that all the parts work together as a whole. There are, of course, innumerable ways in which you can vary the style and intention of your drawings, but to discover what makes a good composition, keep the shapes as simple as possible to start with.

In this drawing of two men running, the arm and leg of the leading man obscured by the body of his companion indicates that he is on the far side. The dog creates a foreground and raises the eye-level. The whole makes a rounded and well-balanced composition.

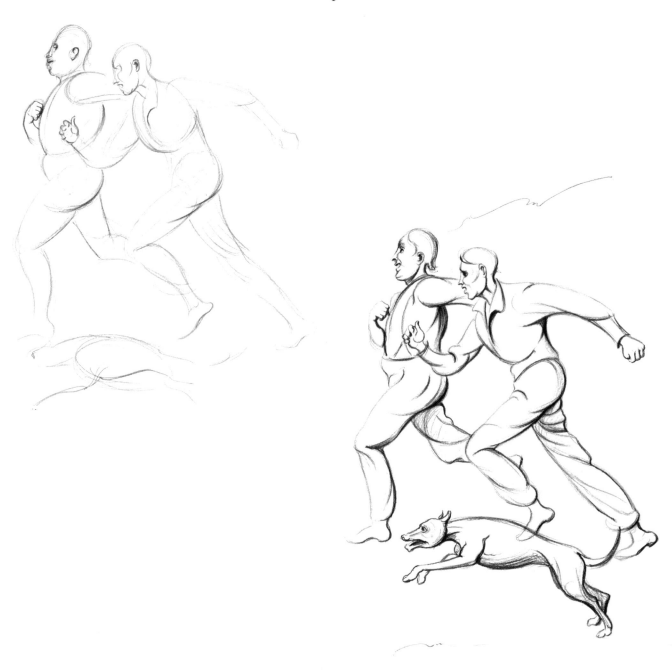

Here, the dog pulling on the leash against the man's arm
forms a triangle with his body. The muscles of his shoulder
and arm show the tension. The skyline sketched in behind fills
out the space and provides a secondary plane.

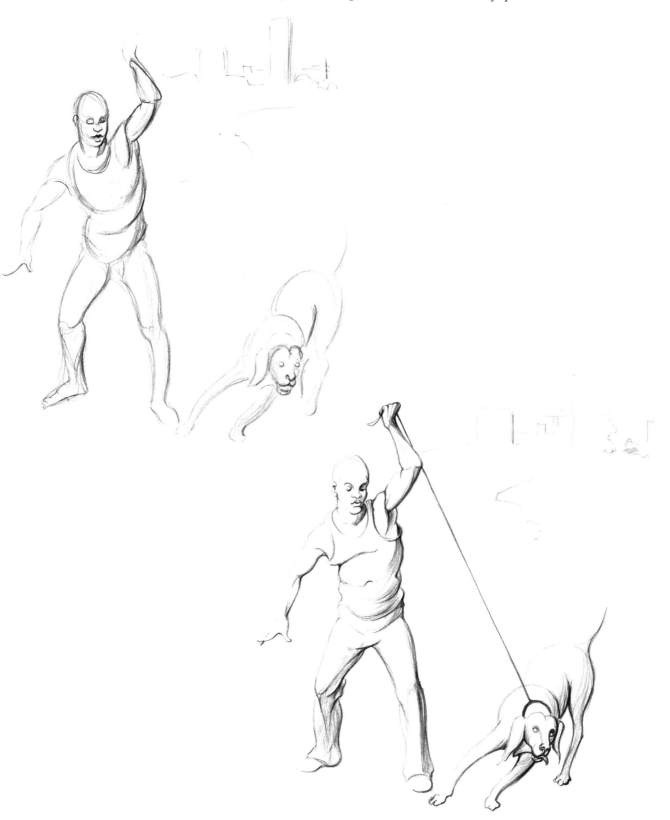

A soft pencil and heavy shading were used for these divers to give them volume. Having established their position in relation to each other, (roughly an inverted triangle), the addition of a diving board, water and a smaller figure in the background creates a feeling of height, length and depth.

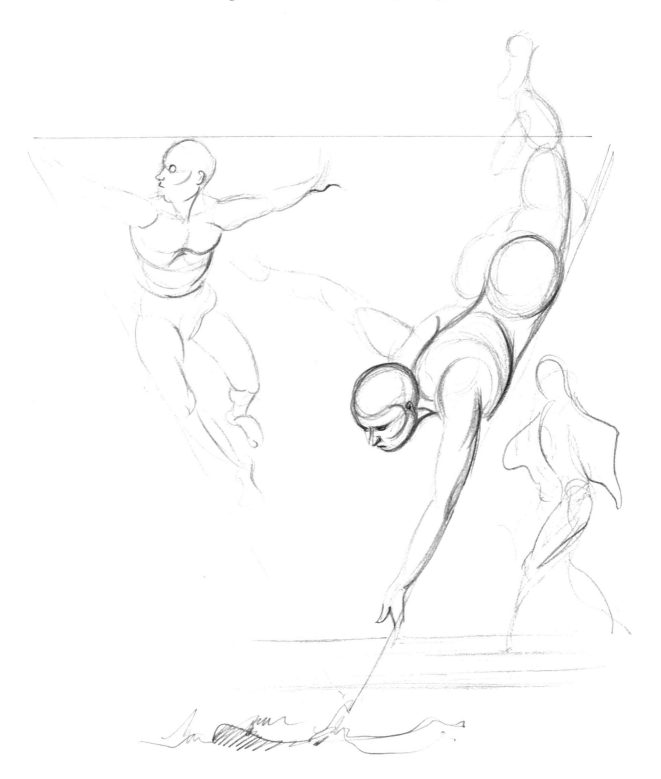

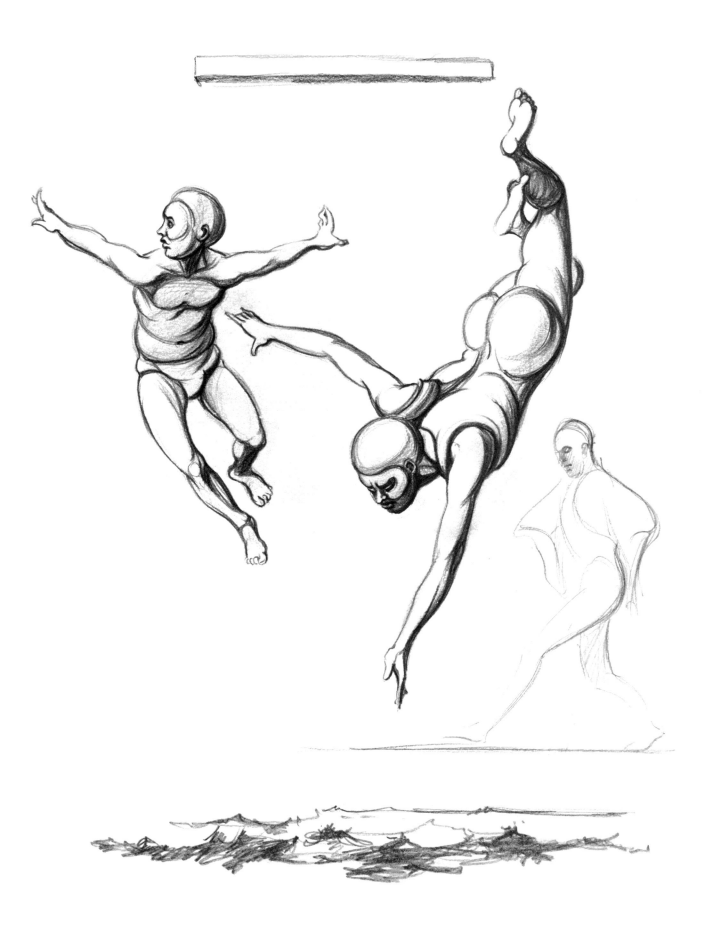

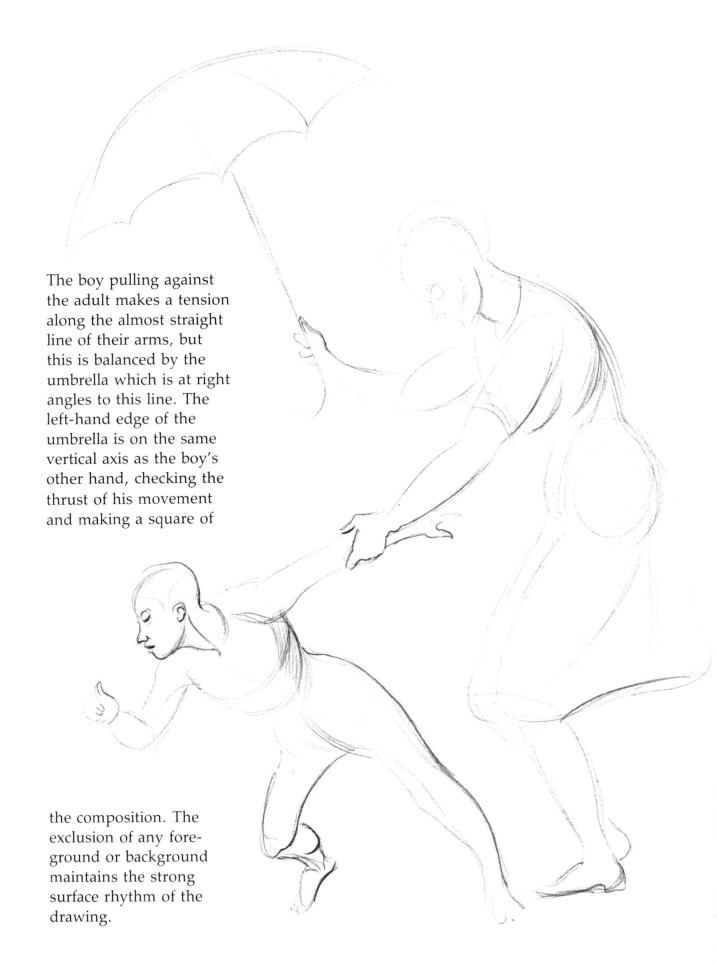

The boy pulling against the adult makes a tension along the almost straight line of their arms, but this is balanced by the umbrella which is at right angles to this line. The left-hand edge of the umbrella is on the same vertical axis as the boy's other hand, checking the thrust of his movement and making a square of the composition. The exclusion of any foreground or background maintains the strong surface rhythm of the drawing.

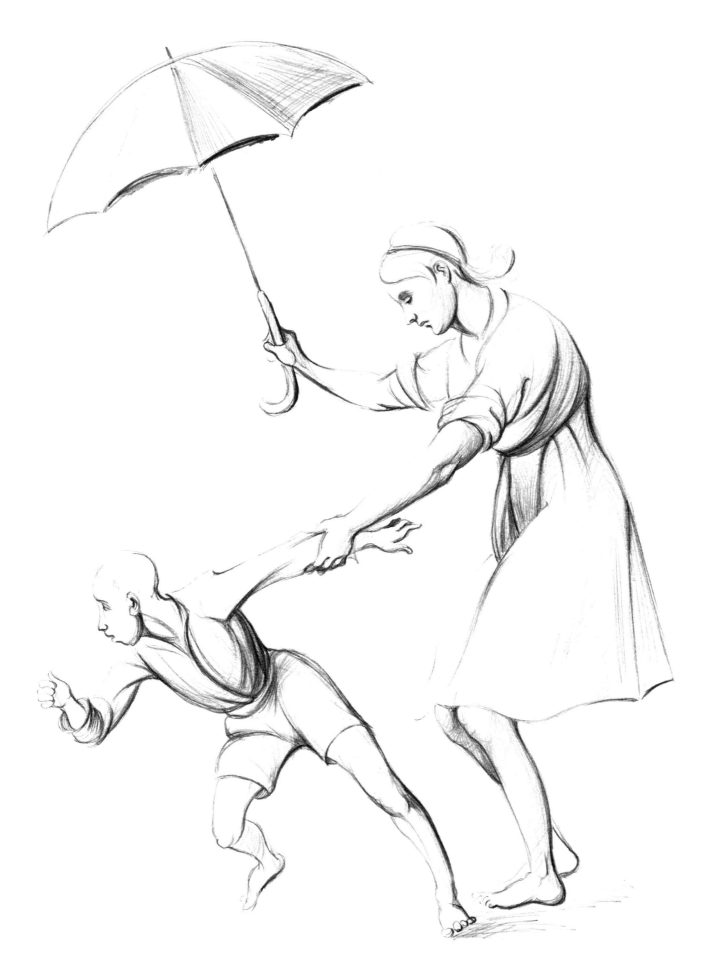

The next three drawings are taken from beach studies. The central composition in each case is a woman and child, linked by a towel which is pliable and can be used to create rhythm.

Here the accent is on the head and upper torso of both figures. The towel forms an arch which binds them together. An alteration in the boy's position improves the rhythm. The lightly sketched background fills out the design but does not detract from the main group.

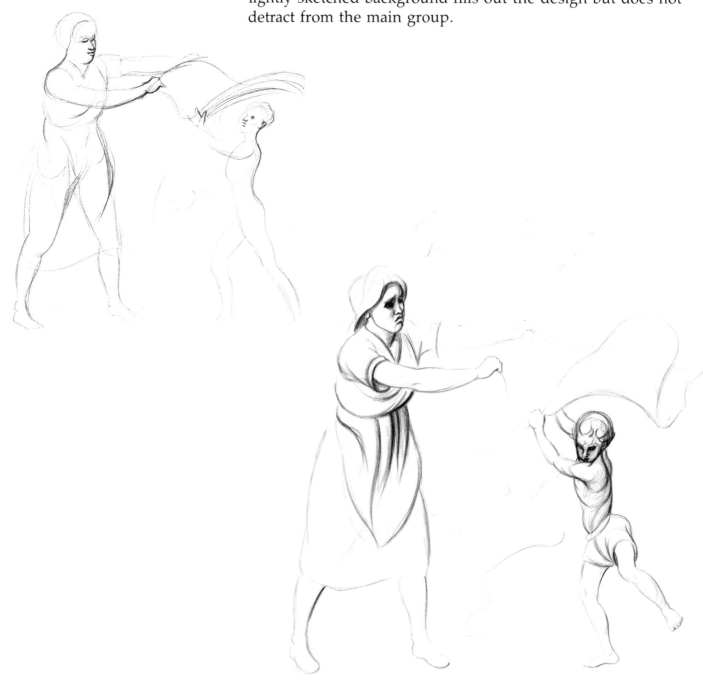

This drawing in red crayon shows a change of intention in the position of the boy's left leg. It isn't necessary to erase such alterations in a working drawing. When preparing a drawing for illustration you may want to do many rough drawings before deciding on the final composition.

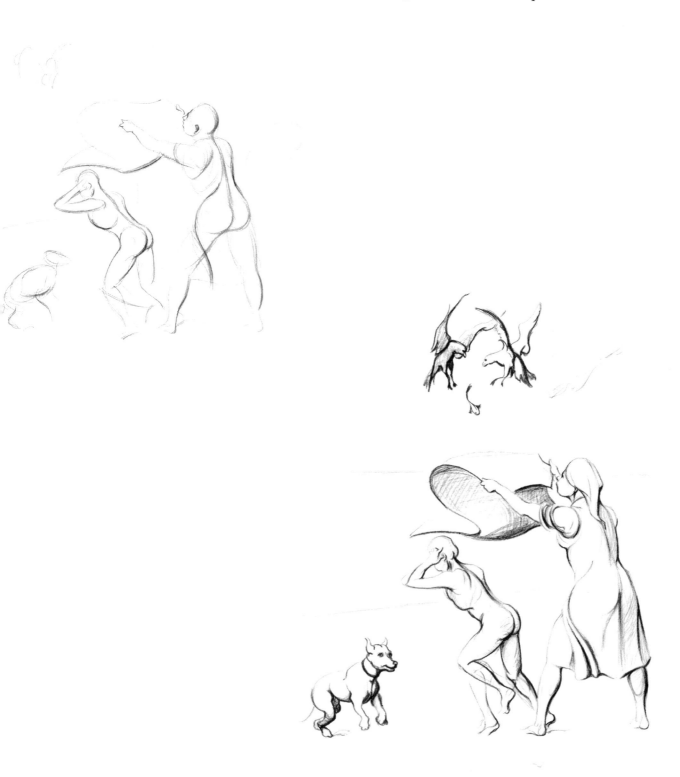

These two figures form a closely-knit unit. The beach umbrella behind them echoes the shape of the hat, its upright handle stressing the woman's slight lean. The effect of perspective is shown here by the small figures receding to the horizon at eye-level, on the same line as the top of the woman's head.

The diagram shows a side view of how standing figures on a horizontal flat plane diminish as they recede into the distance but still share the same eye-level.

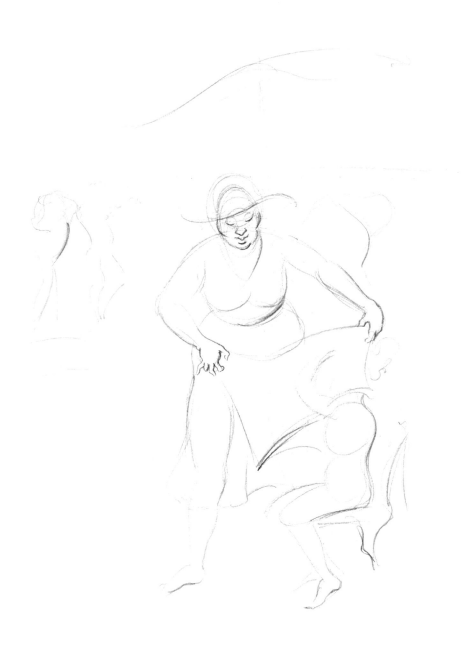

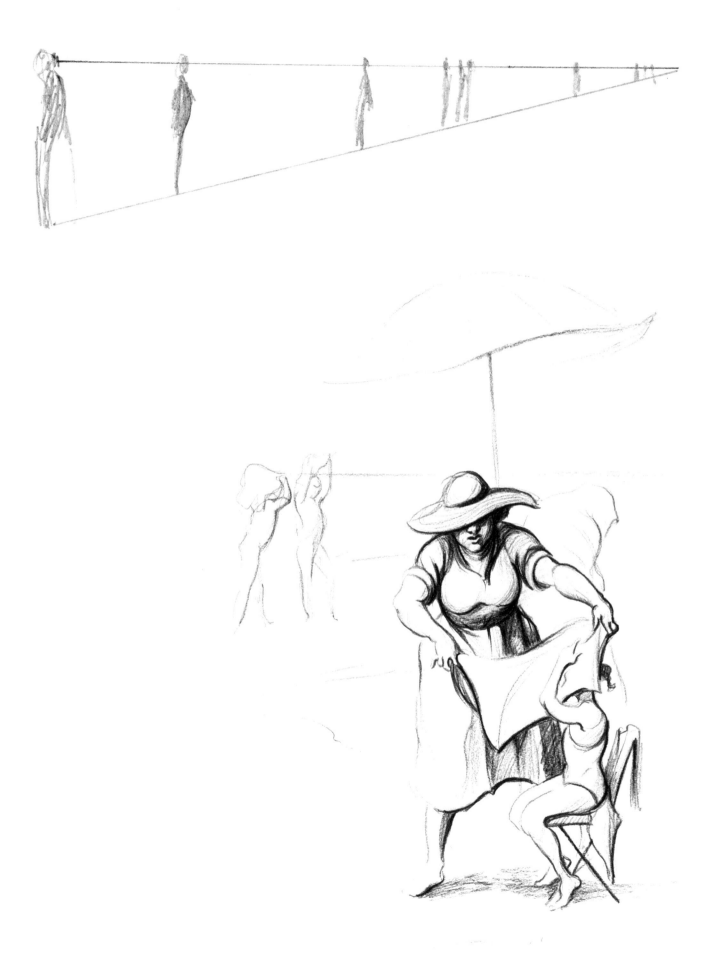

In this rather elongated drawing everything is pulled apart but remains connected by the straight line of the dog's leash. You cannot stretch a composition of this kind too far or it will cease to hold together.

Compare the stretch of this drawing with the compression in the next one.

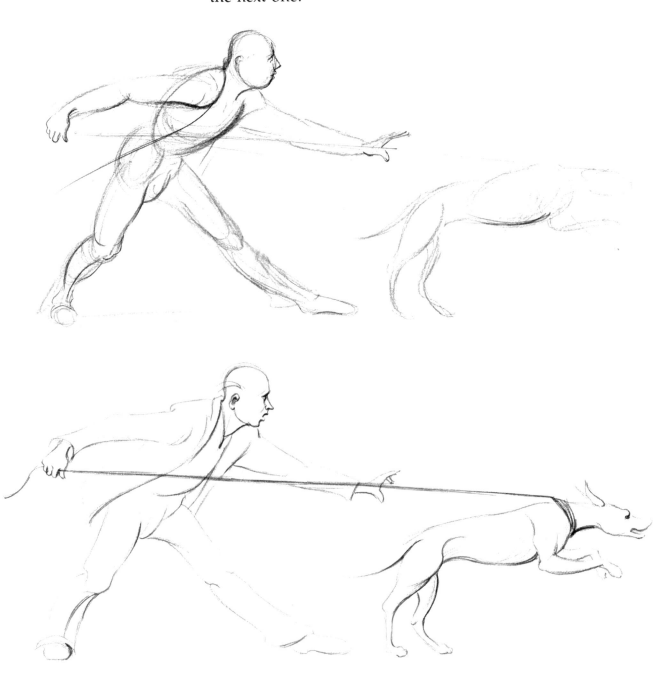

Here all the lines lead up to the baby, and the upper half of the drawing is accentuated. The main points of concentration are on the woman's hand, the man's eye and the baby's thigh. The preparatory exploration for this drawing shows how the figures were subsequently brought closer together to achieve more compression.

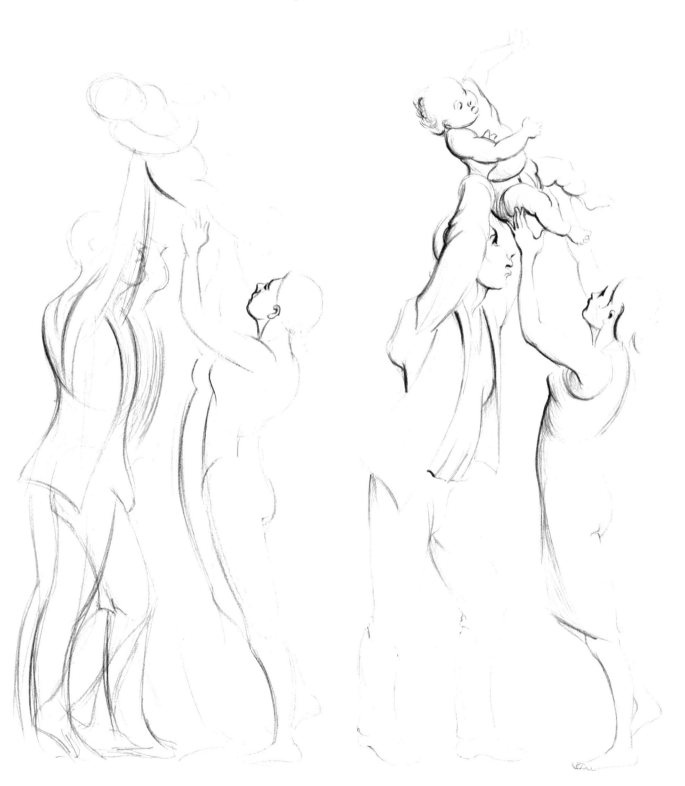

This is another compressed group. The direction of the heads leads the eye to the right and into the background, and the line of the tree then leads back to the figure on the left. The drawing has a rhythmic continuity which does not allow the eye to rest on any one point. In this way you can create a real sense of mobility in your drawing.

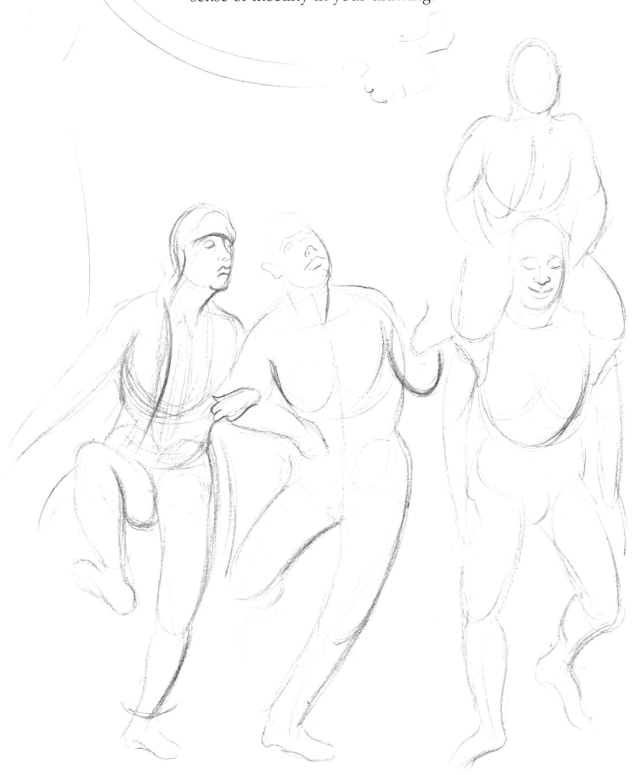

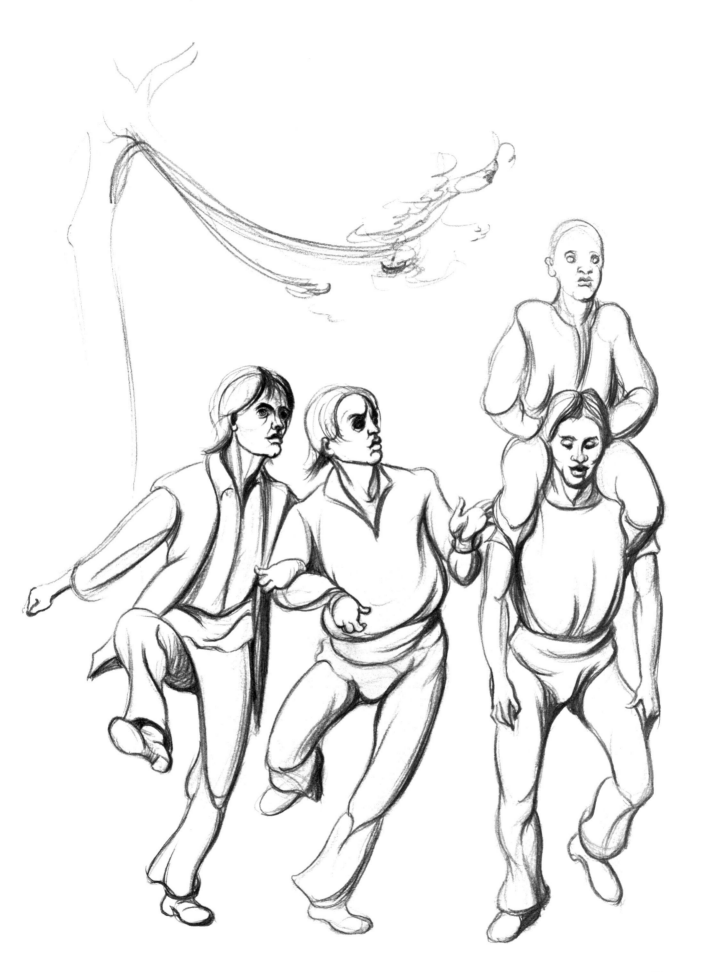

Quick notes

Abbreviated drawings are useful for quick notes, to help you explore different positions or work out a composition, or to use for reference later. Forget about detail and concentrate on the general shape and proportion. If you cannot draw on the spot, store as many impressions of moving figures in your head as possible and then practise committing them to paper. Then experiment with groups of figures.

Do thumbnail sketches of your ideas. If they work on a small scale, they will make satisfactory compositions when enlarged.

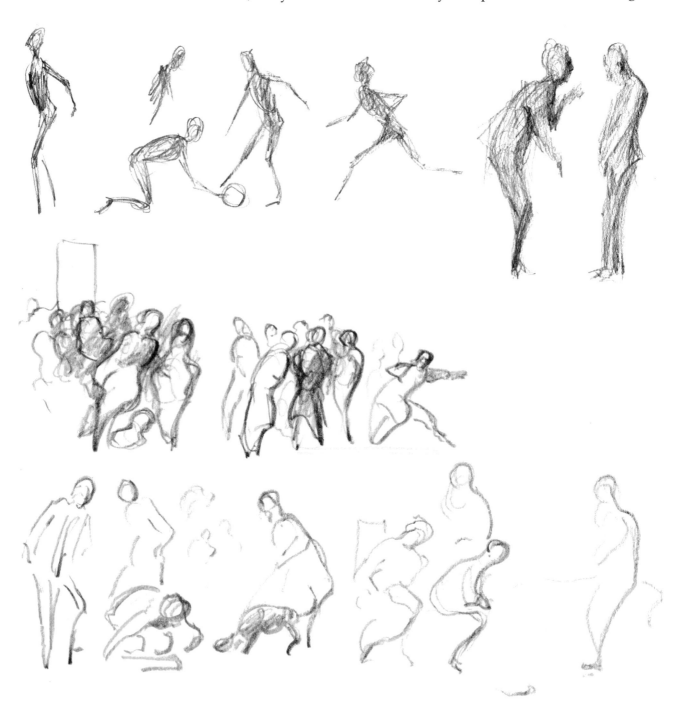